T0112862

Abloh-isms

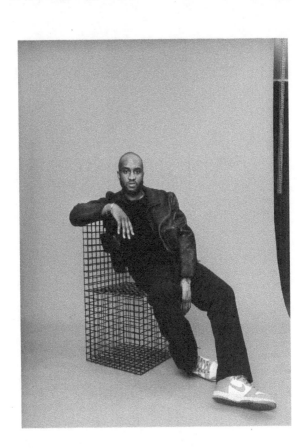

Abloh-isms

Virgil Abloh

Edited by Larry Warsh

PRINCETON UNIVERSITY PRESS
Princeton and Oxford

in association with
No More Rulers

Published by Princeton University Press, 41 William Street,
Princeton, New Jersey 08540
In the United Kingdom: Princeton University Press, 6 Oxford Street,
Woodstock, Oxfordshire OX20 1TR
press.princeton.edu
in association with
No More Rulers
nomorerulers.com
ISMs is a trademark of No More Rulers, Inc.

 PRINCETON ~~NO MORE RULERS~~

Library of Congress Cataloging-in-Publication Data
Names: Abloh, Virgil, 1980- author. | Warsh, Larry, editor.
Title: Abloh-isms / Virgil Abloh; edited by Larry Warsh.
Other titles: Quotations. Selections
Description: Princeton: Princeton University Press in association with
No More Rulers, [2021] | Series: Isms | Includes Bibliographical references.
Identifiers: LCCN 2020037558 | ISBN 9780691213798 (hardcover)
Subjects: LCSH: Abloh, Virgil, 1980-
Classification: LCC NK1412.A24 A35 2021 | DDC 746.9/2092—dc23

LC record available at https://lccn.loc.gov/2020037558
British Library Cataloging-in-Publication Data is available

This book has been composed in Joanna MT
Printed on acid-free paper. ∞
Printed in the United States of America
5 7 9 10 8 6

CONTENTS

INTRODUCTION

Virgil Abloh has operated under many titles: creative director, fashion designer, DJ, architect, engineer, and artist, to name a few. But to define him is to miss the point. Abloh exists in the in-between, the gray area, challenging and defying the confines of conventional categorization. He has invented a world in which the hierarchies and divisions between fashion, art, music, and popular culture are no longer relevant. Both a disruptor and collaborator, Abloh has created the language that defines modern luxury, and has enlightened a generation.

The quotes in this book, pulled from more than fifty interviews, lectures, and other primary sources, showcase the essence of Abloh's brilliant, sincere, and perceptive mind, addressing

themes from his career in fashion and streetwear, his influences and methods, and his creative process. From his childhood in the suburbs of Chicago to his ascension to the role of artistic director of menswear at Louis Vuitton, Abloh has proven himself to be one of the most culturally important figures of our time.

Abloh's early life placed him at the intersection of artistic and cultural movements, popular art and conceptual art. Born in 1980s Chicago, Abloh was part of the last generation to come of age pre-internet, and flourished at the center of DJ, graffiti, hip-hop, and skateboard communities. Initially pursuing studies in engineering, Abloh switched gears when inspired by an art history class, specifically the Renaissance, and went on to complete a master's in architecture. In somewhat of a self-fulfilling prophecy, Abloh observed our culture pre- and post-internet as

a new Renaissance, and an early understanding of the internet and an embrace of social media became key to Abloh's rise.

After completing his architecture degree, Abloh interned at Fendi with his friend and collaborator Kanye West, who he had been working with for nearly ten years, to learn the intricacies of the world of high fashion. The pair quickly drew attention, piquing interest at Paris Fashion Week. Soon after, West hired Abloh as his creative director, working together toward his vision of merging rap, contemporary art, and high fashion—an entry point for Abloh into converging these many worlds at a grand scale. The two forged a close relationship, with West trusting Abloh, rather than the label's art department, to art direct the cover for his and Jay-Z's album *Watch the Throne*.

Shortly after, Abloh launched his first brand,

Pyrex Vision, which he shuttered a year later but which served as an entry point to his next luxury streetwear label Off-White. Within a short amount of time, the brand was widely embraced, worn by Jay-Z, Beyoncé, ASAP Rocky, and Rihanna, among others. Only five years later, he was named the artistic director of menswear at Louis Vuitton, and was the subject of a major exhibition at the Museum of Contemporary Art in Chicago.

Abloh's work widely embraces intersections, references, and influences—from Marc Jacobs and Vanessa Beecroft to Miles Davis, James Brown, and Jean-Michel Basquiat. He often recounts his own early aspiration toward luxury brands like Prada, Gucci, and Louis Vuitton, and his reverence of cultural brands, namely—like most teenage kids of his generation—Michael Jordan. Yet Abloh, leveraging social media, has opened

the doors of luxury to previously ignored, but interested, communities—primarily the Black community and, well, kids—creating a link between the culture that loves Jordans and luxury goods, and has yearned to be included in the narrative, and in the luxury industry itself, which traditionally wanted little to do with hip-hop, sneakers, or Black culture. Whereas luxury brands once held the power in tastemaking, social media gave power to the voice of popular opinion, which put Abloh himself in power.

While Abloh is not the first to create value for a pair of sneakers, he is one of the few who does it well, rivaled only by the value created in the art market. Yet industry conversations around the longevity of streetwear and sneaker products miss the point of Abloh's long-term impact. In fact, the obsession around "what sells" instead of "what are we selling for" is what made the

luxury industry ripe for Abloh's disruption in the first place. As all parts of the industry now scramble to get their own grasp on collaborations, sneakers, and streetwear, Abloh will always hold his place as the shaker that drove new luxury forward.

Yet, as explored in this book, Abloh has spoken against the idea of "new," stating that it's designed to keep people like him out of industries like luxury. Ironically, the energy that Abloh brought to luxury fashion is perhaps the most refreshing the fashion industry has ever witnessed, and in spite of any criticism, this is where Abloh's true subversion lies. In reality, traditional luxury power holders and institutions were not positioned to understand the wave of disruption that Abloh was a part of. Many, if not most, still aren't.

Abloh has, in many ways, transcended the term "disruptor." Throughout his career, fueled by his energy to manifest change, he questioned the foundations of popular culture, inserted his ideas, and created cataclysmic changes to its DNA. It is within this transformed environment that he, and those for whom he has paved the way, are now able to create. As Abloh himself states, "The word 'disruptor' doesn't sit well with me because it's not articulating exactly my frame of mind. I stay away from words, I'm more about actions. Words are often just another box to be put in."[1] Despite the many boxes in which he has been placed—fashion designer, architect, DJ, artist, and, indeed, disruptor—at

1 "The Designer Interview: Virgil Abloh," Net-a-Porter, https://www.net-a-porter.com/en-us/porter/article -56046fbd2262dd7d/fashion/art-of-style /off-white-virgil-abloh.

the core of Abloh's long-term legacy, the effects of which we are only beginning to see, is that he brought true authenticity and openness to the most exclusive societal mechanism: luxury.

LARRY WARSH
NEW YORK CITY
DECEMBER 2020

Abloh-isms

Early Years

I'm this African kid, born in a suburban white neighborhood outside of Chicago, inspired by Guns n' Roses and NWA at the same time. (3)

———

I was African and my dad worked on the docks in shipping logistics and he got the bright idea to go to Chicago where they were exporting all these goods. And through sheer will, he managed to go there, get my mom there, and have this life for me there. But only when I was a teenager [returning to Ghana to visit] did I see this dynamic. Looking down the street and walking over exposed gutters, I realized that this is who I am. (11)

———

My mom was sewing when she was eight years old, and she still sews today. So I grew up with her saying, "you don't buy clothes, you make the clothes." (11)

———

I have vivid memories of going back to Ghana and looking out the window and being super appreciative—but being, like twelve—like, what if my dad hadn't made this one decision to take this leap of faith to go to this new country? I would be the kid on the side of the street in Africa with no clue what was going on in the rest of the world. (5)

When I was younger, I was into DJing, graffiti, hip-hop, skateboarding and I love it that now I can just take my passport and hop on a plane and go see what's up with those scenes everywhere. (27)

———

Being born in 1980 I was part of the last generation that was pre the internet. Before the internet made all knowledge easily accessible, information was guarded, slow, and very much propped up the gatekeepers and their rulebooks. (4)

I'd been in a way Americanized: teenager, 1990s, skateboarding. I'm trying to identify with just being black. (11)

——

Until I was seventeen I didn't know all that much. I was my most authentic self—I was just a sponge. I'm trying to revert to that point, that point is what I call the "authentically real." (3)

——

Sometimes I still feel like the seventeen-year-old version of myself who didn't believe I could be a designer with a capital D. (3)

——

When I studied engineering at the University of Wisconsin in Madison, it was the humanities classes that I had put to the side that ultimately started me on this path of thinking about creativity in a much more cultural context—not designing for design's sake, but connecting design to the rhythm of what's happening in the world. (38)

———

I took an intro to art history. That's when the bulb went off. ... My parents weren't versed in art. And I thought art was a trophy or a symbol of wealth. (47)

———

Kanye and I are brothers for life. We started on the same mission of being kids from Chicago trying to push beyond being boxed in and have music as our only form of expression to the world. (24)

———

Kanye is my mentor. I think he's a generation's mentor. Before I met him, I wasn't even interested in being creative. I thought I was just going to work some regular job. (27)

———

I was a kid that was buying streetwear T-shirts. I was DJing. I was learning graffiti from this book called *Subway Art*. These things are what made my aesthetic. So, I decided not to forgo those things as I got into my career. I decided to make a career that celebrated those exact things. (1)

———

My upbringing included zero art. (3)

———

Influences and
Inspirations

Pick your mentors and understand what makes their work tick. (30)

I've come from a specific set of mentors, everyone from Vanessa Beecroft to George Condo to Tom Sachs. (37)

Marc Jacobs—an *American*—came along and made his own articulation of high and low and somehow broke down the mystique and the barrier. That's my North Star. (5)

I considered Prada or Gucci or Louis Vuitton iconic. I loved those brands. I couldn't afford them, but I aspired to them. (11)

It was during my early days within
architecture school that I was told that an
architect should be a jack-of-all-trades. That
was all I needed to hear. From that point on,
I realized that I did not need to ditch my
love for Wu-Tang, Green Day, Alien Workshop,
and Mies van der Rohe, etc. but proceed
applying them all together. (4)

———

You have to have mentors, dead or alive. …
What most people won't tell you is that the
people you look up to didn't invent
it themselves. (30)

———

"New" is a farce to me. It's a critique intended to keep people like me out. I'm not trying to pretend that I'm inventing something that's never been seen before. My work exists because I'm inspired by the work of others. (3)

———

Any person you can cite—Steve Jobs, Karl Lagerfeld, Michael Jordan—they are not common names because they did it nine-to-five. There are people on Earth that dedicate themselves to their practice or whatever. I've always been like that. (17)

———

My mentor in the DJ space has been Benji B. (24)

I think one of the greatest contributions
to black art is the invention of two turntables
and a mixer. (2)

I used to DJ and get my hands on my dad's
records—Fela [Kuti] to James Brown to Miles
Davis. I was only into the fashion that
intersected with the niche cultures I was
into—my favorite "fashion" brands were
[skateboard companies like] Alien
Workshop, Santa Cruz, and Droors. (12)

A-Trak was my idol and I started out
in turntablism. You know, Roc Raida, Invisibl
Skratch Piklz, Mix Master Mike. My cousin had
a record shop, Deal Real in Soho, and that's
where Kanye met A-Trak. That's where I come
from, like any teenager during those years
being interested in music and Technics
1200s and Vestax mixers. (24)

———

The one thing that the world could use
is more role models. (26)

———

My role models are my friends. (40)

———

I'm constantly inspired by my friends and the people I surround myself with and the cities that I'm traveling to. All the movements are made up by my brain trust. None of us sip the Kool-Aid. We're all individuals; we're all critics; we all look at things from a discerning eye, and I synthesize those things. (32)

Kanye West's album *The Life of Pablo* is like a DJ cheat sheet. It works everywhere, every time. (13)

To me, [Kanye West is] this generation's most important living artist. Fashion or music or pop culture, those things aren't broad enough terms to encapsulate someone who wakes up and lives and breathes it. (42)

Black influence has created a new ecosystem,
which can grow and support different types
of life that we couldn't before. (2)

I'm not that much of a basketball fan, but
Michael Jordan sort of made me. (8)

I think that any guy that's born around the
year 1980—anywhere around the globe—is
affected by the brand of Michael Jordan. (8)

My friend Chris Eaton and I used to be so
obsessed with Jordan that we were drawing
Nike shoes and sending them to Nike.
And Nike would be like, "Oh, we
don't accept designs." (12)

———

The aesthetic of skateboarding comes from
not being too informed, and that, to me,
is authenticity. (3)

———

Simply seeing an advertisement will influence
someone to buy, but it also speaks to a much
larger context than that—what
they believe in. (44)

———

The generation in New York City just before mine was one where the ideology of Pop art was crashing together with Conceptual art right at the same time—and they were in turn building on the legacy of the previous generation, the legacy of someone like Duchamp. My generation was able to feed off all this, stir the pot and mix in the sociological ramifications of what art is and how it can break the barrier of high culture and relate to real life, regular people. (1)

I was four years into a five-year engineering degree, and about to go into structural engineering when I took an art history class that blew my mind. (3)

———

Studying the Renaissance completely rewired my brain. (3)

———

I started getting into the philosophy that the present—our generation grown up before and after the internet—may be a new Renaissance. (1)

———

I love the millennial spirit. They'll make
an Instagram where they're Goth, and the
next week they're dressing Harajuku.
That's freedom. (5)

———

When I started, I couldn't beg a fashion writer
to write about my project. But with Instagram,
I took an open-source tool and made it my
magazine. I once said to Kevin [Systrom,
Instagram cofounder], "You made it possible
for me to have a fashion brand without
using the traditional system." (12)

———

Instagram is a specific moment in time. It is the vehicle for how we as a global community share images. This will inevitably change, but for the moment this is our main channel to share globally. Some of its moral complexities are not the fault of the medium that we use to share. Instead I think it is how the medium highlights some of our innate human tendencies that is sometimes alarming. (4)

———

I went to architecture school not to learn how to design buildings, but to design a spoon. (37)

———

Once I started learning the safeguards of the art and the design worlds and what the prototypical artist or architect was, I learned that I needed to—in a way—be subversive, and to embed in my work the messages of what an African artist looks like, or what a black artist looks like. (11)

I think increasingly from this point forward, there are going to be moments and places where the public is going to interface with the questions of "What is architecture?" "What is art?" (11)

I was also going into the luxury stores because to me they were like museums. (11)

———

Critical discourse is important, I love critics.
(3)

———

Bad design inspires me ... bad design makes you stop and question stuff ... and sometimes, bad design might even be better. (43)

———

I'm exploring the self-endowed freedom to
create. Everyday language, grammar, and my
own personal philosophies are equal territory
to mine as the art canon. (4)

I'm not looking towards a new demographic.
I'm looking towards the demographic
I came from. (32)

Streetwear, Fashion,
and Design

I'm an American black kid in fashion, making "streetwear"—that streetwear label is put on me. At first I rejected it, and then I sort of owned it because I realized that I could redefine the term. (3)

———

I didn't make a conscious decision one day that I wanted to be a designer. (12)

———

I think that fashion should be politically aware, and anyway I can't make something that doesn't *mean* something. (3)

———

People want to judge the clothes. But before that, I had to deliver a message about humanity. (11)

———

As soon as you put on one garment, it speaks to your personality. (23)

———

People need to experience what the brand means for the T-shirt to make sense. (28)

———

The inherent idea that clothes are what represents you gives us a palette to either be superficial or very curatorial with taste. It's an art form. (23)

———

You're either playing into fashion or you're
reverting to it. (23)

———

[Streetwear is] an extension of a way of
thinking about the physical world, and it's a
way of making. It started from skateboarding,
graffiti, street culture—but over time, it has
risen into a global movement within
young people. (1)

———

Streetwear is a sentiment. (1)

———

[Supreme] is among my favorite brands for its art direction. It's connected to culture. The music playing in there … It's art direction. It's art. You're barely getting that at a high-fashion brand. They should be charging me double for that. (28)

———

My career has been about learning, and communicating emotion through design. (1)

———

I love fashion; it's like a petri dish where all these different ideas converge. (3)

What's there to be insecure about? Life is the
hard part. Fashion isn't. (10)

I have this brand Off-White, only to
tell stories. (30)

I decided that Off-White, the name itself,
could be a perfect metaphor for understanding
that things are not so cut-and-dried, nothing
is single source, nothing is black and white.

(38)

Fakes don't bother me. The goal of Off-White is not to buy Off-White. It's to know about it.

(47)

For me, design is about whatever I find is worthy to tell a story about. (5)

Of course, the history of fashion is important, but you can't say this dress that comes down the runway has relevance to the person ... the homeless person, the regular person walking to their nine-to-five job. (11)

There has to be a conversation between consumption. I look at it from a generational perspective. If you ask your grandparents how many winter coats they have, they may have two—maximum. If you ask someone in their thirties, they may have four. If you ask someone who is seventeen, they may have six. (34)

———

Luxury fashion sells an image: that's what we do. It's neither authentic nor inauthentic; a designer is sifting through images so that people can buy into an idea. (3)

———

One of the true concepts of streetwear is using whatever means you have to make clothing. (28)

Ultimately, the consumer is more important than the gatekeeper: that's why streetwear has become so popular even in high fashion. (3)

There are so many consumers who know what's happening in high fashion, but high fashion looks down at them for not being worthy. (3)

As a fashion designer for an international luxury brand, you get control of the brand equity. Being inside of it, through their internal system, I have the chance to reach both tourists and purists and to present my reasoning. (11)

———

In the past generation of high art and high fashion, it's like, "Put a wall around it. Put a layer of mystique around it. Keep it on a really tall white pedestal. Put a vitrine box under it." It's what a gallery is—a white cube. But what all these kids have figured out is that what's happening outside the cube and on the street, whether it's graffiti or real life, is just as valuable as what's in there, and it's about zigzagging back and forth between the two. (40)

———

Something like luxury doesn't have to directly correlate to the European thing or money thing. I'm making a thing that a kid can consume and gain knowledge and perspective. (11)

Hierarchy is the human trait that gives license
to absurd human behavior with no cause. (4)

———

That's what fashion, art, architecture—these
hallowed layers, the last to conform—need:
to just be open-minded. (11)

———

I think that's the success of Off-White.
I haven't made a distinction between the
design world and the real world—I've just
immersed myself in both. (5)

———

Does fashion have to be new? What is new anyway? Does fashion have to be new to be valid and relevant and important? People often lob "it's been done before" as a critique but without asking themselves those questions. "Newness" has become the barometer by which we judge things in fashion. Does your jacket have three armholes? (3)

———

There are so many clothes that are cool that are in vintage shops and it's just about wearing them. I think that fashion is gonna go away from buying a boxfresh something; it'll be like, hey I'm gonna go into my archive. (19)

———

Fashion was a vehicle for my ideas. When I started, it was the easiest subway train to graffiti without a cop in sight. It is only one communicative device, one soapbox to stand on and speak from. All the arts have value. I can't imagine not scaling the heights of those that interest me and laying a foundation for future ideas. We have one life to live. (4)

—————

I like that streetwear has a place. (8)

—————

Because I came from outside of the fashion industry, I don't have the luxury of creating collections in a traditional way. (5)

—————

I knew of Fashion with a capital F, as this thing that happened in far-off places that was intellectual, high culture, not for me, not for the masses. I thought of fashion as hard to describe—and it was *supposed* to be hard to describe, because there should be that barrier for it to feel important. (5)

———

I was very well aware that as a fashion designer, I was a square peg in a round hole. It's like someone who is really messy and tries to clean their place up to throw a dinner party. Everything is in order, but then you go to the bathroom and you're like, *Why is there a cereal box in the bathtub?* (5)

There's this insurmountable mountain of legends that precedes us—this guardianship that doesn't allow new to come in. It's often an old guard reinforcing the old days. (5)

I think [Kendall Jenner, Gigi, and Bella Hadid and I are] trying to bridge the gap between the old and the new: They're recalling the glory days of the biggest supermodels, but they're doing it in the modern way. I'm trying to do the same thing with design. (5)

Fashion is a great industry, but it's sort of asserted by an unknown voice. We all know it, and we all see those that are tuned into it. But, that's my motivation, and I actually believe it doesn't matter. It's about an expression, a sort of feeling of I made it, or I'm here, I've arrived. (8)

———

Ultimately, what I'm trying to do is validate the genre that I'm put in, which is streetwear. (22)

———

Streetwear is like disco. When it started, disco was cool but the term didn't age well, and neither did the genre. All of us who are classified as streetwear, it's up to us how it's defined and that's why I hope the evolution of Off-White is so apparent. The definition of Off-White, it's the grey area between two concepts, streetwear and "proper" fashion. (22)

———

Fashion is an innovative process. You do it and you do it again and then you do it again and then you do it again. That repetition sort of inspires a new approach every time, so it's just trying to become more precise. (8)

———

That way of designing—to develop everything from zero—comes from a different time. (5)

In Chicago, there's always been a relationship between black culture and luxury brands. People would do almost anything—even getting shot—for a jacket, a shoe. So I developed this pattern that references Duchamp, Corbusier, Martin Luther King, Dr. J. I'm using these because I thought that in fashion, you always use these esoteric, random things to mark the brand as luxury. And I was like, instead, "Let these be a gateway. Let someone be inquisitive and learn." I thought high fashion should have more intellect; I thought that this was an industry where art could be merged with critical discourse. (11)

There was this message board for the downtown scene at the time called Splay, and if you weren't involved with it, you couldn't message on it, you could only view it. But everyone was on it—A-Ron, Roxy Cottontail, Leah from Married to the Mob—the whole Orchard Street retail mafia. (12)

———

Fashion only addresses the small square footage in someone's living space, which is usually the most amount of money per square inch. You are buying clothes that add up, but what about the rest of [the] living environment? (34)

———

I'm interested in what the future living space looks like. You know, from a Le Corbusier sense—*the home is a machine for living*—that framework where a bedroom is just as much as a kitchen, just as much as a living room, as a closet. (43)

———

What we do is called design. It's not limited to being called "streetwear." Design-is-design. The moral of the story is beware of whatever box you're labeled as. Challenge it. Defy it. Do not be defined by it. (18)

———

I decided if "streetwear" was gonna be the sign of the times I was gonna define it rather than be defined by it. (19)

[Streetwear's] time will be up. In my mind, how many more T-shirts can we own, how many more hoodies, how many sneakers? (19)

I would definitely say [streetwear is] gonna die. (14)

Right now I think we're stuck in the ways of the first generation of streetwear that is based on exclusivity. That doesn't matter anymore. Any kid that wants it doesn't care if a million people have it—they still want it. (31)

———

I'm not a fan of people waiting in line and not getting product. I am generally disinterested in sneaker culture. Disinterested by the fact that when a cool sneaker comes out, I have no idea how to get it. I don't have the time to figure it out. (31)

———

There are more shoes trying to fill the bigger demand, but there's not that same multiplier of cool creativity that comes from the likes of Supreme, Palace, Stash, and Futura. Literally, there's like five people that are in their own space that have something to offer this multiplicity. It went from 100 to 10,000 to 100,000. (31)

The scene has transcended the sneaker itself. (31)

The street [is] where you get the relevant ideas to real people. (46)

You can go to a job interview in a hoody,
you shouldn't be hired depending on whether
or not you have the right costume or the
right persona. (45)

———

Clothes are just tools to make a collage about
yourself so that people can understand
what you know. (45)

———

As a designer, you get confronted with the
term of your generation, which you
have no control over. (19)

———

A piece of clothing is more important than the fabric it's made of—it's representative, it means something. (19)

I don't care if my aesthetic creeps into Foot Locker. It's my job to come up with the next idea after that. I want to be in the space that incubates new design ideas, and then that can just trickle down into the marketplace. That's my approach. It's like the concept car in an auto show. It actually doesn't work as a car, but it looks like it could and it serves needs that aren't practical. I'd like to see that mentality in all different disciplines, and sneakers is one where I can particularly exercise that train of thought. (31)

That line has been crossed. Enough shirts have
been sold and enough Instagram posts have
changed the ecosystem, so you can't go back.

(21)

What we are actually doing, is showing the
fashion world that American men, let alone
Black Men, know how to really get busy
when it comes to the fashion game.
We can't be erased. (19)

Off-White was great for my consciousness because it gave me my own realm. For all of my collaborative projects, the unit has a say but now I have a platform to have an idea, not second-guess it and share it with the world. I feel like it has extended my life because if the world builds up it could exist long after me. (22)

———

I want to create on the highest platform. I want to go to the fashion Olympics. (27)

———

Point of View

From my perspective, I'm trying to stand for a generation. You know, each generation has designers who go along with it. I think it's explicitly the fact that I split my time among many things that gives me the point of view to know [what I'm doing is] relevant. (10)

I've realized that being contradictory is more authentic than being consistent. (3)

In a way I'm still the ... kid that thinks that Nike will never call. (31)

I am the same person now as I was in high school. I like the consistency. (5)

I am a little bit too old [to be a millennial],
but I went to enough school to be able to
understand it. I keep myself young—like
a fountain of youth! (9)

———

The only thing I feel like I really am is
an architect. (43)

———

I am inherently linked to the time that I was
born into, a time rooted in contemporary
art and the subcultures of hip-hop,
skateboarding, and graffiti. (4)

———

Where you were born gives you your access
point to make things, or think things. (16)

———

I'm just an assistant to the people that came before me, trying to add to the design that goes forward for the next generation to continue. (45)

I came into this being born in America, identifying with being African. What I look at in the mirror, what my people look at, is drastically different from the messaging I've been consuming. (11)

African doesn't equal that you're a singer, you're a basketball player. I come from this design world. (11)

I always had in my mind that an architect with a capital A or a designer with a capital D was somebody other than me. Those kind of people never looked like me. (3)

———

Take the ten biggest architects of all time, not too many of them are black and from Illinois. (3)

———

Being too consistent is a sham, it's fairytale, it's not real. Human beings are naturally at odds with themselves. We say one thing, we feel and do something else. Understanding that has been super liberating. (3)

———

"Diversity" brings to mind people from different backgrounds holding hands—I say fuck that. It's too small minded. I'm not even into the construct of race—it's a dead-end for me. Screw skin color. My generation is all about irony, about humor and piss-taking. (3)

Our generation is rapidly unthreading every notion that generations in the past agreed upon. Questions about the environment, consumerism, value, necessity, health etc. Plastic is now a curse word. Cigarettes are as taboo as cocaine. Everything is being questioned, which I imagine makes a better time for an artist to introduce new ideas. (4)

In the years between 2009 and now, a new consumerism has emerged. (9)

———

No one owns anything anymore. (9)

———

I think [Chicago is] a place where you can find your voice without having to proclaim that voice. And there's a strong sociopolitical lineage with the huge South Side, which forced black communities to organize. You either believe in the doomsday scenario or you want to effect change, and what we see in an Obama or an Oprah—that strikes a chord on the positive side with a number of us who are from there. (5)

———

People like me were marginalized in the fashion establishment when I started four years ago. I was on the fringe because what I was doing was too new, the attitude was like, "This is not even fashion." What are you doing, putting jeans on the runway? (3)

———

Being a black American in Paris fashion, there's no context for someone like me, no path to follow. If I was Japanese, I'd know how I'd fit into the system, same if I was Belgian or even American and white. But I don't know any other black kid who designs clothes and shows in Paris, do you? (3)

———

I personally feel pretty much in the middle
of all extremes in America. (33)

———

Please treat all races, all humanity in a
respectful way. (33)

———

I'm just an eager kid who looks at every day
as a possibility to make something and leave
a good impact. (17)

———

I've never been one that felt like the doors
were closing—I'm an optimist so I don't
even recognize that, that's how I got
to where I'm at. (19)

———

I [shy] away from giving myself a title but I do like the idea of picking "creative director." (22)

I think our generation has learned that more stuff isn't necessarily necessary, it's how we use and how we attach ourselves to the things in the world that are important. (15)

Evolution is as obvious as it is natural. (4)

I'm sort of in this midlife phase where
I'm pondering becoming more content sitting
on a couch. As a workaholic, that's the central
conundrum. I'm sort of absorbing these
milestones in my career, but I'm also
welcoming the idea that, yeah, maybe I don't
travel so much; maybe I don't take on as many
projects; maybe I spend more time at home
with my kids. Now that I see what my
trajectory is, who knows? I might be
open to being boring. (5)

———

DJing is my only peace of mind. (24)

———

I'll be DJing after I'm done designing or
doing anything else. (24)

———

I'm just a kid, really. (28)

———

Methods

I use collaboration as a medium to experiment. (1)

———

The best thing with Off-White is that no two seasons have to look the same; there's no linear continuity. I removed that from the DNA. (3)

———

I often use the phrases Tourist and Purist to describe my approach to work. The purist knows everything about art history, every museum in every country and what's going on across the world. And the tourist, in this context, well they know what a Dookie chain actually is. (2)

———

When an artwork moves effortlessly from the tourist pages of the NY Post to the most purist eyes, then you do have a truly unifying moment. Those moments come only when stars align. (4)

———

The General Recipe:
1 part desire a.k.a. a reason for existing
1 part provocation of convention—the
unraveling of the accepted facts of the current
time period by a new generation
1 part the notion that an everyday object is
an art object regardless of the context
Stir with a whisk of minimalism that reduces
the sum of all of these parts down to a clear
and transparent final product that
communicates the process of its creation
to the viewer whether they are a tourist
(a newcomer to art elitism) or purist
(seasoned elitist). (4)

———

When I started my first brand, I bought
hooded sweatshirts on sale from Champion
and Ralph Lauren, and I added my
logo on top. (3)

My door is always open. There's no hierarchy.
I don't shut the door and get people to ask
permission to come in. (10)

I rebranded my brand with art. (37)

I always say, "I love the first 'no.'" That first
"no" gives me the premise for adjusting and
correcting to get to the end goal. (38)

I'm using the models as people, not just bodies to make my clothes look good. (10)

Work is relaxing to me.
I'm happy making things. (10)

I like taking details and swapping them around. (10)

My context is not leaving fashion or doing anything else. It's subscribing to four blank walls, and inserting ideas that represent my thinking. (37)

That's the liberating part about having an art practice underneath everything that people may have seen from my body of work. It's devoid of commercialism. (1)

———

From the beginning, I approached the idea of design from a grassroots level. I removed this idea that it's somehow detached from the consumer. (5)

———

I basically work at a feverish pace. (30)

———

I don't sleep as much as normal people do. (41)

———

I do everything with an architectural way of thinking. (9)

I also use my life experiences to inform the work. Often a conversation or a lunch on the side of the road can be the most impactful inspiration of a fashion collection or an artwork, even more than my degrees that I obtained twenty years ago. (4)

One of the biggest premises in my practice is that it's OK to contradict yourself; it's human. (5)

Hard work, good ideas and persistence will undoubtedly lead to success. (15)

In my solo work, the only thing I'm trying to display is the ideas, my artistic philosophy and the generation I'm part of. (1)

In a world that's made up of all these different constructs it's actually the most authentic and pure expression when a work ends up in a space it was made with no regard for. (2)

Making the work is important obviously,
but communicating the work is just as
important. It's how you make people
believe in what you do. (3)

———

I'm working on a vocabulary, an ethos,
I'm not just creating an aesthetic. (3)

———

Logos give you a feeling; they add something
to the object. (3)

———

I would consider myself a logic, which
would be a tier above a logo. (4)

———

I like ready-mades, I make things out of other things. I like that it forces you to think about the context of an object, not just the object itself. (3)

———

I try to find ways to have objects be a conduit for what I have to say. (4)

———

I consider my practice a modern form of graffiti. (4)

———

I love the general air of unknowing around my larger practice. It's my smokescreen. (4)

———

In my practice, by design, I think without limits. Messages are meant to be traversed. (4)

———

I might be driven by anxiety. As a creative, you're always fighting against not having any ideas. That might be the driver. (7)

———

As a believer in evolution and the breakdown of barriers, I am using my practice to show that art conversations break down barriers: art/not art, high/low, etc. (4)

———

In this new era, I often question the validity
of even looking at the period of time when
high-art and mass culture were kept distinctly
separate. The only value that I see in keeping
those worlds distinct is providing economic
benefit, which is fleeting. (4)

———

For me, Off-White is a creative studio,
a recording system of time and culture,
politics and art. (33)

———

Off-White is my blank canvas. (27)

———

If I have a fully charged phone, I can do anything. (7)

———

Steve Jobs would be psyched, and I run my life through [my iPhone]. (13)

———

I do believe that, sometimes, when I'm distracted is when I think of a good idea. So, you can't always call it a distraction. It's the chaos of life. (7)

———

I base whole collections on a glass of rosé with a friend or brunch or people-watching at Café Select [in New York]. That's my style of creation. It's inclusive, not exclusive. (42)

———

I embed myself into a culture. (9)

———

I wanted ... to reapproach these iconic designs in a way that takes the energy of the historical side and replaces it with something that a young person can identify with. (9)

———

I think the internet has created a sort of utopia. I look at it as potential. (9)

———

I regularly use Helvetica in Off-White to
reclaim or reprogram a tangible object. (37)

———

I can ready-make fashion better than fashion
can be projected to me, and that was the
epiphany: to make something in the system
that has different ideals than the system,
to influence change from a
different direction. (11)

———

1. watch the news cycle.
2. understand the news cycle.
3. insert idea.
4. see what works.
5. edit idea.
6. insert new idea.
7. live in new world.

(20)

I feel like I'm figuring things out, but I don't
feel accomplished yet. I still feel like I'm
an intern. (12)

I am not the kind of person who is painting in his studio, of course. But within the Instagram generation there is no strict rule. The millennial spirit is: One day you are a stylist, one day you are an art director. Those kids are not waiting for a title to explain who they are. They just do things. (33)

———

We have this thing social media that we can [use to] communicate and we are just a world of young people, no longer just a niche culture in one city of young people. (45)

———

Kanye wasn't going to put his art form in the hands of the art department at the record label. So he was like, "I am going to hire you, and let's literally work on this 24–7, laptop in hand." (12)

———

It's important that I have the ability to design products that can affect change or feel like a good contribution to the world at large. (15)

———

With stamina, there's a part of your brain that just wants to shut off. You know when it wants to, and when you reach that sort of peak, you realize how much your mind can control what your body has a capacity to do. You have to just stare at it, and if you hold that sort of attention, you realize it falls away. Because that barrier can't withstand time. (36)

———

If you have an awesome Instagram, I'll follow you, DM you and say, "Hey, do you want a job?" And if you are self-motivated, you're going to get promoted in two seconds because that's ultimately the shot I wanted when I was a kid. (17)

———

Credit doesn't do anything to me. It literally has no feedback. I don't get any gratification. I don't read any reviews. It doesn't matter. (23)

If you removed every classification of a profession, then it becomes about what's your type of character. Some people are more analytical; for some people, it's about problem solving. (26)

[The quotes are] basically humor. A couple of people laughed [when I brought up quotes] and that's literally the point of that tool. To insert humanity through conversation ... you open up when you laugh. (30)

I can basically design with a keyboard, I don't need Photoshop or anything else. (30)

I use the means that I have to do what I can. (31)

I choose to make the reality that I see in my head. (1)

Making an Impact

My motivation this whole time has been to represent for a generation—I'm still thinking about the kid that couldn't get into fashion shows. (19)

———

Young architects can change the world by not building buildings. (16)

———

I do create some residual noise, but the noise is like jazz music in the background. It actually helps me think of new ideas and provocations based on reactions the work generates, the question of whether something is considered good or bad, what is considered design or not, what is considered art or not. (4)

———

I will probably always have a chip on my
shoulder … thinking I have to defend myself
against non-believers who think my work isn't
valid. Doing it anyway is one of my main
motivations. (3)

That's what a large part of the constantly
working and never sleeping was about, to
disprove that little voice in my head that
was like, "It's impossible." Because that
was almost destructive to me. (5)

My project embedded at the core, I'd say, is humanity and education. We can use design, we can use trends, we can use brands to share good ideas to share information. (45)

———

My freedom comes from within. (4)

———

Contemporary news dictates a lot. I want to reflect the time. Womenswear gives me an opportunity to be a relevant reflection. To not speak from the male voice. (47)

———

We were coming off the elections while I was conceptualizing the collection, and the women's marches were happening. Like every modern person, I'm seeing things on social media, and I was, like, "This all needs to be documented in a serious way within fashion, not just a logo on a T-shirt." (38)

———

I have a very particular viewpoint on politics. It is from a young perspective. I feel helpless, but I realize that I am not helpless if I raise my voice. (33)

———

I needed to step up to the plate and contribute something to culture. (23)

———

My work's main objective is to interrupt the pre-existing timeline of contemporary art by challenging its fundamental principles so that when I'm no longer here, there will be more room to redefine the arts than when I started. That's my own measure of success. Not self-service but serving the whole instead. (4)

———

I believe that coincidence is key, but coincidence is energies coming towards each other. You have to be moving to meet it. (7)

———

You can want to build a spaceship, but you're only building a plane. By the time that you can actually go to space, then you feel something different emotionally. It makes you think about things clearly. (8)

I don't believe in titles, I believe in work. (8)

The critics and editors at their magazines are not gonna go anywhere, but underneath them is a vast set of people who vote with their money. (3)

I am interested in this new cultural world that we have been handed, that processes politics and art in a different and democratic way. (9)

———

I take pride in the fact that there's a kid who's living in, you know, Alabama, who never thought something like this was possible for him, almost to the point that he made life and career decisions to find some other thing he was passionate about. But all of a sudden, because I'm here, he knows [he can do it too]. That's why the Harvard lecture exists. I'm not doing that for myself. I'm doing it to be a beacon of hope for someone. This is the legacy of any artist or creative: you want to make sure that your work makes an impact. (10)

———

Put yourselves in my shoes. It's super weird
to have this light on me, I'm not that special.
You guys, you have all the resources. You guys
are born at a very awesome, distinct time. I
think this is the renaissance. Don't get sort of
trapped into this, "Everything sucks, the world
is coming to an end." That's just an internal
mechanism basically to chill. When you don't
have to put yourself out there, you can wake
up every day and come up with excuses.
But ... *it's exactly the opposite.* (30)

———

I wish that when I was a student, one person would have given me one ounce of advice that wasn't: "The rest of your career will be an uphill battle." But instead: "There are all these shortcuts that you can take." (6)

———

Part of the reason that I'm here is because I would go into the [Louis Vuitton] store and not be able to afford what I wanted. That aspiration gave me my work ethic. I would go as far as to say that if Louis Vuitton bags weren't as expensive as they are, I wouldn't work as hard as I do now. (10)

———

I didn't see any designer making things that looked like me. I would be in the stores buying fashion, I'd be in the stores buying brands. But it was only once I had the blind naïveté to start making things and developing my own language that I was creating things that I would put on the same pedestal as brands. (11)

———

I used to try and prove myself to the naysayers, the critics, to the people who said that Off-White wasn't valid or whatever, but then I realized that those people are powerless when it comes to the community I'm speaking to. Now I focus on the legacy I'll leave behind. (3)

———

I realized I was measuring myself against the brands that have huge corporate backing, and that I could create a brand that could speak to them eye-to-eye, and then sort of change the tide. (11)

———

I'm interested in random kids from the urban city, middle America, black kids into skateboarding and graffiti, but who want to participate in fashion, in the art world. In previous generations, there weren't that many people from the same sort of position that I am, on any sort of scale. I'm trying to inspire a generation of kids who largely weren't taught to believe that you could do these sorts of things. (32)

———

[Kanye and I] hit these seminal moments where there's a change and a shift in the understanding of what the black projected image is, and how powerfully it can be represented. (2)

Fashion is in large part perception. Certain things are placed on certain pedestals just by committees, you know? My goal is to break down certain pedestals and put other things on them and see if they work. (32)

I'm looking for something that is open-minded and modern. Lead us to better solutions for the future. (15)

I'm excited to see what we do in this next chapter because the strides we made in the last ten years are too insane. (19)

───────

We've seen a culture shift. We've seen skateboarding go from an illegal thing to socially acceptable. We've seen hip-hop go from dangerous to alluring and I saw an empty seat. No one younger is going to grip it and rip it. I'm going to do the work. (23)

───────

In the time that I'm around, whether it's
in a cultural position between arts or music
or fashion or something like that I want to
represent the most real—the hands
down most real. (24)

———

Part of my concept is to have a dialogue with
fashion with a capital F. [I have that dialogue]
by nature of showing what's happening,
what's modern, and what's happening
in the streets [and showing it] next to
all the things that we've considered
the epitome. (25)

We all have to remember it's how the work
ages[,] not how it's received now. (4)

—————

If everything is more utopian, I don't know if
art would be better. It might be worse. (27)

—————

Only good things happen once you begin. (39)

—————

The only failure is not to try. (30)

—————

Art and Creativity

Anyone who has a will to create is an artist.
(37)

Unraveling life's manmade myths at the
earliest age possible is the hard part. Once one
has unraveled the prisons we build around our
own minds and abilities, there is true creative
freedom. After that the world becomes
crystal clear. (4)

I grew up thinking images were fact. I now have the impression that images are like memories. They are slippery and fluid. The context of an image like with anything else can alter its message. (4)

———

In general, my criteria for design is that the object needs to be relevant; not just for now, but also for tomorrow. (4)

———

If an object is not desirable, I question its reason for existing. (4)

———

I love designed "things" or anything made with a POV. Any art I own gives me tons of "vibes" at the moment. (13)

Authenticity today is something that has roots or origins in a specific past. (4)

In my artwork, my main goal is to redefine what we consider to be generic, to operate on the version of the work from the community that designed the original, which can be a murky concept in human history. (4)

My brand started in the streets and the alleys of the internet—I come from a different school of thought about clothing. I understand people see it as fashion. To me, this is an art practice. (47)

———

One day, I'd love for someone to refer to me as an artist. (22)

———

Every medium is equal. (4)

———

The internet has democratized information and equally the need to actually own. If you ask me, it is the Wild West for artists to dictate new modes of operating. (4)

The black artist is defining the present, showing this new form of expression in an old space that's never seen anything like it before. (2)

An artwork is a pure idea attached to an existing rationale. An artwork for the art world is any idea attached to an invoice. (4)

You can't hide from artists being brands. (1)

If you squint your eyes, essentially an artist's signature is like a brand. (1)

I had a wish list of female voices and Jenny [Holzer's] was at the top … because it's a nonwavering voice that creates powerful messages that are also easy to understand and accept. (38)

I was completely inspired by [Jenny Holzer's] willingness to work together, which in turn made the process very invigorating and precise. We both felt compelled to address the current political climate, we wanted to make our point of view center stage, let people have a moment with our expressions and to have them exist. (8)

———

"Two heads are better than one" is something I firmly believe in. Collaboration is what happens with everyone in my offices and I believe in extending that outwards. I look for someone that has an authentic voice that, together, we could make something that we couldn't make individually. (7)

———

Life is collaboration. Where I think art can be sort of misguided is that it propagates this idea of itself as a solo love affair—one person, one idea, no one else involved. (1)

———

I wanted to be an architect. I thought it was sexy. It checked all my personal boxes, but then I found that it's a genre of design which doesn't keep up to my pace, and doesn't offer the same kind of gratification. When people try to label what I do and say like "DJ" or like "architect" or "fashion designer," I find it pointless. It's all just different sorts of creative. (8)

———

It's only in the modern sense that everybody started categorizing: architect/researcher, interior designer/landscape architect, industrial designer/painter, graphic designer … they're all just terms. you get titled this and you can do that. you could be a writer, you could be a painter, but architecture to me is a term for all things, holistic design, having a point of view. (43)

———

It is a myth that creative projects exclusively
get created in a test tube. (4)

———

You don't have to sit in your studio and throw
a dart and hope that it lands on the bull's-eye.
If you actually walk up to the dartboard, you
can just place it in the bull's-eye. (5)

———

I'm always reluctant to be anti-evolution. (31)

———

My art practice is the convergence of all creative disciplines into one matter. (4)

———

Sometimes you need to rearrange the furniture in your head. (5)

———

Over-intellectualizing the mundane is my creative exercise. (4)

———

Your ego does not want to fail, so why would you put forth your ego? (34)

———

I look at everything I own as an art piece. (37)

———

Irony is a tool for modern creativity ... there's a reason why we all probably look at 60 memes a day. (16)

———

If we thought of creativity like tech, without the iPod 1, would we get to the iPhone 7? (30)

———

I like the conundrums: Nothing is fact. (34)

I think my personal work is to make [sure]
the everyday things have a design or an
opinion attached to it or done with a
specific point of view. My entry
point is streetwear. (23)

I also think of the brain as a muscle. Creative
problem-solving is an exercise—you can't
simply be noncreative for three months and
then sit in a brainstorm session trying
to merge ideas. (36)

I feel like now is a tremendous time in culture. I feel like it's the Renaissance. I feel like Bernini just sculpting away, defining a moment of enlightenment. (17)

What seems preposterous actually becomes the new norm. (19)

I'm just doing it because I like to stay busy
and creative. If I run into someone in a club
or during the day at brunch, I'm always
thinking in my head, "Man, let's do something
together." I love developing ideas. Ultimately,
this became my world by accident.
Trying to avoid a day job by having
ideas ... 30 ideas a day. (22)

———

You create art so that people can build
on top of it. (35)

———

I create from a point of view of resonance.
I made this, I don't even know if anyone
bought it, but I know as soon as it left
my idea that it resonates. (23)

Perfectionism doesn't advance anything,
ironically. (30)

On one hand I would want to push something
that makes it easier for artists to be artists, but
on the other hand a lot of the time artists
become who they are because they have
something to battle against. (27)

You just have to come with a unique perspective, which is actually simple. Look at the market, see what's out there and propose something that's a point of difference. (29)

———

Do opposites. It just feels better. (30)

———

We don't sit around to critique, we create. (27)

———

SOURCES

1. Ascari, Alessio. "One of Us." Interview. *Kaleidoscope Magazine*, issue 33 FW18/19. http://kaleidoscope.media/article /virgil-abloh.

2. i-D Staff. "Listen in on a Phone Call between Virgil Abloh and Arthur Jafa." *i-D Magazine*, no. 357, September 16, 2019. https://i-d.vice.com/en_uk/article/43k37p virgil-abloh-arthur-jafa-interview-the-post-truth-truth -issue.

3. Cronberg, Anja Aronowsky. "Does Your Jacket Have Three Armholes?" Interview. *Vestoj: On Authenticity*, issue 8. http://vestoj.com/does-your-jacket-have-three-armholes/.

4. Cattelan, Maurizio. "Bananas Are a Contemporary Mirror." Interview. *Flash Art*, March 23, 2020. https://flash---art .com/article/bananas-are-a-contemporary-mirror -maurizio-cattelan-in-conversation-with-virgil-abloh/.

5. Van Meter, Jonathan. "'My Job Is to Be a Spirit Leader': Behind the Scenes with Virgil Abloh." *Vogue*, May 14, 2019. https://www.vogue.com/article/virgil-abloh-interview -off-white-louis-vuitton.

6. Abloh, Virgil. "Insert Complicated Title Here." Lecture at Harvard University Graduate School of Design, Cambridge, MA, October 26, 2017. https://www.gsd.harvard.edu /event/virgil-abloh/.

7. Welch, Adam. "Career Advice from Off-White's Mr. Virgil Abloh." Interview. *Mr. Porter*, January 24, 2019. https://www.mrporter.com/en-us/journal/lifestyle/career-advice-from-off-whites-mr-virgil-abloh-388524.

8. Celeste, Sofia. "Backstage with Virgil Abloh." Interview. *NOWFASHION*. https://nowfashion.com/interview-backstage-with-virgil-abloh-22383.

9. "'No one owns anything anymore': Virgil Abloh and Architect Rem Koolhaas on the Future of Living, Working, and Selling." *System Magazine*, issue 10, April 20, 2018. https://www.buro247.me/culture/insiders/no-one-owns-anything-anymore-virgil-abloh-and-arch.html.

10. Van der Broeke, Teo. "Virgil Abloh: 'I now have a platform to change the industry … So I should.'" Interview. *GQ*, September 13, 2018. https://www.gq-magazine.co.uk/article/virgil-abloh-interview-2018.

11. Koolhaas, Rem. "After Architecture." January 7, 2019.

12. Bettridge, Thom. "Group Chat: The Oral History of Virgil Abloh." *GQ Style*, March 4, 2019. https://www.gq.com/story/virgil-abloh-cover-story-spring-2019.

13. "Virgil Abloh Interview." *Office Magazine*. http://officemagazine.net/interview/virgil-abloh.

14. Cowen, Trace William. "Virgil Abloh on Tyler, the Creator's Grammy Categories Critique: 'Exact Sentiment When I Hear the Word Streetwear.'" *Complex*, January 27, 2020. https://www.complex.com/style/2020/01/virgil-abloh-tyler-the-creator-grammys-comments-genre-distinctions.

15. Parsons, Elly. "Virgil Abloh Is on the Hunt for the Next Big Thing in Sustainable Design." *Wallpaper Magazine*, February 10, 2020. https://www.wallpaper.com/lifestyle /virgil-abloh-evian-activate-movement-interview.

16. Abloh, Virgil. "Everything in Quotes." Lecture at Columbia University Graduate School of Architecture, Planning and Preservation, New York, February 6, 2017. https:// www.arch.columbia.edu/events/455-virgil-abloh.

17. Lewis, Tim. "Virgil Abloh: The Red-Hot Renaissance Man Shaking Up Fashion." *Observer*, June 30, 2019. https:// www.theguardian.com/global/2019/jun/30/virgil -abloh-the-red-hot-renaissance-man-shaking-up-fashion.

18. Tweet. @virgilabloh. December 19, 2019. https://twitter. com/virgilabloh/status/1207863749253718017?ref_src =twsrc%5Etfw%7Ctwcamp%5Etweetembed%7Ctwterm%5 E1207863749253718017%7Ctwgr%5E&ref _url=https%3A%2F%2Fwww.complex. com%2Fstyle%2F2020%2F01%2Fvirgil-abloh-tyler-the -creator-grammys-comments-genre-distinctions.

19. Allwood, Emma Hope. "Virgil Abloh: 'Streetwear? It's definitely gonna die.' " *Dazed*, December 17, 2019. https:// www.dazeddigital.com/fashion/article/47195/1/virgil -abloh-end-of-2010s-interview-death-of-streetwear.

20. Instagram post. @virgilabloh. May 8, 2020. https:// www.instagram.com/p/B_7a9hiJNqU/?utm_source=ig _web_button_share_sheet.

21. Porter, Charlie. "Virgil Abloh—'The world is looking for the second coming.'" *Financial Times*, June 20, 2018. www.ft.com/content/9cdf0158-730e-11e8-b6ad -3823e4384287.

22. Salter, Steven. "Virgil Abloh's Remixed World." i-D, November 6, 2015. https://i-d.vice.com/en_us/article /evnqm4/creation-curation-and-collaboration-virgil -abloh39s-remixed-world-us-translation.

23. Barna, Daniel. "Virgil Abloh on Why Fashion Matters." *Nylon*, November 23, 2016. Https://www.Nylon.Com /Articles/Virgil-Abloh-Interview.

24. Bakare, Lanre. "Virgil Abloh on DJing and Streetwear: 'Fashion is about to take a left turn.'" *Guardian*, July 12, 2016. https://www.theguardian.com/fashion/2016/jul /12/virgil-abloh-dj-streetwear-fashion-kanye-brooklyn.

25. Dike, Jason. "Virgil Abloh Discusses His Favorite UK Streetwear Brands, Club Culture, and the Hacienda Influence." October 25, 2016. https://hypebeast. com/2016/10/virgil-abloh-london-streetwear-interview.

26. Boardman, Mickey. "Virgil Abloh's 'Agressively Creative' Agenda." *Paper*, December 12, 2017. https://www. papermag.com/virgil-abloh-aggressively-creative -interview-1-2516947565.html.

27. Dominique. "Knotoryus Talks to Virgil Abloh." KNOTORYUS, November 19, 2015. https://www.knotoryus.com /articles/archives/18155.

28. Miller, Jamie. "Virgil Abloh on Breaking the Rules of Fashion with Off-White." *Sleek*, January 2, 2017. https://www.sleek-mag.com/article/virgil-abloh-off-white/.

29. Howarth, Dan. "'Mies van der Rohe had a lasting effect on my aesthetic,' Says Virgil Abloh." *Dezeen*. June 23, 2017. https://www.dezeen.com/2017/06/23/virgil-abloh-interview-mies-van-der-rohe-influence-off-white/.

30. Bains, Arsh. "Virgil Abloh's Lessons for Creatives." *36 Chapters*, November 20, 2017. https://36chapters.com/virgil-ablohs-lessons-for-creatives-6ca91764f90a.

31. Woody. "'Interview': Virgil Abloh x Sneaker Freaker." *Sneaker Freaker*, November 20, 2017. https://www.sneakerfreaker.com/features/interview-virgil-abloh-x-sneaker-freaker.

32. Delistraty, Cody. "Virgil Abloh Is Searching for Virgil Abloh." *Esquire*, January 30, 2017. https://www.esquire.com/style/mens-fashion/a52288/virgil-abloh-profile-interview/.

33. Marx, Ilona. "Off-White's Virgil Abloh: 'Three years ago, no one could tell, if street fashion would last or not.'" *Sportswear International*, July 18, 2017. https://www.sportswear-international.com/news/portrait/Interview-Off-Whites-Virgil-Abloh-Three-years-ago-no-one-could-tell-if-street-fashion-would-last-or-not-13537.

34. DeAcetis, Joseph. "Interview: Virgil Abloh's 'Democratic Design.'" *Forbes*, December 2, 2017. https://www.forbes.com/sites/josephdeacetis/2017/12/02/interview-virgil-ablohs-democratic-design/#46198f6f127d.

35. Bettridge, Thom. "Interview with Virgil Abloh." *032c*, issue 32, Summer 2017. Also appears in Jack Stanley, "Virgil Abloh Says 'Snobs & Haters' Feed His 'Reference System' in '032c' Interview." *Hypebeast*, June 14, 2017. https://hypebeast.com/2017/6/032c-virgil-abloh-interview.

36. Bettridge, Thom. "2017: 2:03:32, 2018: 2:01:39: We Salute Marathon World Record Breaker Eliud Kipchoge." *032c*, September 19, 2017. https://032c.com/beyond-the-limit-eliud-kipchoge-wins-the-berlin-marathon-and-speaks-with-virgil-abloh.

37. Judah, Hettie. "Exclusive: Interview between Virgil Abloh and Takashi Murakami." *Numéro*, April 4, 2018. https://www.numero.com/en/art/interview-virgil-abloh-off-white-takashi-murakami-gagosian-gallery-london-exhibition-collaboration-art-fashion#_.

38. Trebay, Guy. "Virgil Abloh, the Mixmaster of Fashion." *New York Times*, September 28, 2017. https://www.nytimes.com/2017/09/28/fashion/virgil-abloh-off-white.html.

39. Payne, Teryn. "Virgil Abloh Talks His Fashion Journey, Off-White Conception, and Career Advice." *Teen Vogue*, January 31, 2018. https://www.teenvogue.com/story/virgil-abloh-interview.

40. Graham, Georgia. "Virgil Abloh: Question Everything." *Office Magazine*, December 3, 2018. http://officemagazine.net/virgil-abloh-question-everything.

41. Singer, Olivia. "Virgil Abloh: The Vogue Interview." *Vogue*, March 26, 2018. https://www.vogue.co.uk/article/virgil-abloh-vogue-interview-april-issue.

42. "When Bazaar Met Virgil Abloh." *Harper's Bazaar*, March 26, 2018. https://www.harpersbazaar.com.au/fashion/virgil-abloh-interview-16106.

43. Neira, Juliana. "Virgil Abloh in Conversation with designboom." *designboom*, December 12, 2018. https://www.designboom.com/design/virgil-abloh-interview-spazio-maiocchi-12-12-2018/.

44. McGarrigle, Lia. "Virgil Abloh Is Here to Break Barriers & Question Everything." *Highsnobiety*, December 3, 2018. https://www.highsnobiety.com/p/virgil-abloh-interview-kaleidoscope/.

45. Wong, Kevin. "The Movement That Brought Him to Louis Vuitton." *Hypebeast*, June 12, 2018. https://hypebeast.com/2018/6/virgil-abloh-interview-hypebeast-magazine.

46. Collins, K. Austin. "How Virgil Abloh Conquered Streetwear and Took Men's High Fashion by Storm." *Vanity Fair*, August 1, 2018. https://www.vanityfair.com/style/2018/08/virgil-abloh-louis-vuitton-designer-director.

47. Ferrier, Morwenna. "Kanye West Collaborator Virgil Abloh: 'My brand started in the alleys of the internet.'" *Guardian*, March 10, 2018. https://www.theguardian.com/fashion/2018/mar/10/interview-virgil-abloh-fashion-designer-off-white-princess-diana.

CHRONOLOGY

1980

Virgil Abloh is born in Rockford, Illinois, to Ghanaian
immigrant parents. He immerses himself in skate,
rock and roll, and hip-hop culture, all of which he
will draw on throughout his career.

1998

Abloh deejays as Flat White at festivals, fashion parties,
and rap gigs—even playing opening sets for Travis
Scott.

2002

Graduates from the University of Wisconsin-Madison
with a bachelor's degree in civil engineering.
Abloh is introduced to Kanye West at the age of twenty-
two and becomes his creative consultant, working on
tour merch, album covers, and set design.

2006

Receives a master's degree in architecture from Illinois Institute of Technology, where he was introduced to a curriculum, originally established by Mies van der Rohe, formed from the notions of Bauhaus, which enabled Abloh to learn how to converge the fields of arts, craft, and design. These notions, merged with contemporary culture, make up his interdisciplinary practice today.

2009

Abloh and Kanye West intern at Fendi, earning $500 per month to learn the basics of fashion design.

2010

Officially assumes the role of creative director at Donda, West's creative agency.

2011

Abloh art directs the album *Watch the Throne* by Jay-Z and West, an achievement that earns him a Grammy

nomination. The album cover is designed by Riccardo Tisci, then the creative director of Givenchy, a role Abloh was rumored to be up for after Tisci's departure in 2017.

2012
Launches Pyrex Vision, his first line of luxury-priced streetwear, which sets him on the path to creating Off-White. Also this year, he launches Been Trill with Matthew Williams of ALYX and Heron Preston, which is eventually sold and helps fund future projects.

2013
Abloh founds Off-White, which quickly becomes one of the most sought-after brands in the world, combining ideas of streetwear, luxury, art, music, and travel.

2014
Launches womenswear for Off-White and begins showing his men's and women's collections during Paris Fashion Week.

2015

Abloh's womenswear operation gains steam when
 Beyoncé wears a palm-print sweatshirt with the
 word "Nebraska" on it, an homage to Raf Simons's
 Fall 2002 Virginia Creepers collection, in Nicki
 Minaj's video for "Feeling Myself."
Off-White is nominated as one of the top eight finalists
 for the LVMH Prize in Paris.

2016

Abloh is inducted into the BoF 500 "The People Shaping
 the Global Fashion Industry" list, and is one of the
 top five nominees in the International Urban Luxury
 Brand category at the British Fashion Awards.
Also this year, he launches his first furniture collection
 "Grey Area" in Milan, Italy, and curates an exhibition
 from his furniture collection for Design Miami at
 Art Basel.

2017

Abloh drops "The Ten" collaboration with Nike, win-

ning Shoe of the Year at the FN Achievement Awards. The shoes are hailed by many as the best sneakers of 2017.

He is also nominated as one of the top five nominees in the Swarovski Award for Emerging Talent category at the CFDA Awards, and is selected as a special guest to show his Spring/Summer 2018 Men's Off-White c/o Virgil Abloh Collection in Florence, Italy, during Pitti Immagine Uomo 92. He also wins the Urban Luxe Brand Award at the British Fashion Awards.

Abloh works with Ben Kelly on a touring set that was exhibited at the Open Eye Gallery (Liverpool, England) and then at the Somerset House in London. Abloh also collaborates with Ben Kelly on a new installation called Ruin, which was displayed at Store Studios in London.

Delivers lectures at Harvard Graduate School of Design; Columbia University Graduate School of Architecture, Planning, and Preservation; and the Rhode Island School of Design.

Wins the International Designer of the Year Award at the GQ Men of the Year Awards.

2018

Abloh is named artistic director of menswear for Louis
Vuitton, the first African American to lead the brand's
menswear line. He is also named one of *Time*'s 100
Most Influential People in the World.

Collaborates with Takashi Murakami on exhibitions
at the Gagosian Gallery in London, Paris, and Los
Angeles.

In March, Abloh showcases his exhibition *Pay Per View* at
Kaikai Kiki Gallery in Tokyo.

For the second consecutive year, Abloh wins the Urban
Luxe Brand Award at the British Fashion Awards.

Abloh is also nominated as one of the top five nominees
in the Womenswear Designer of the Year and Mens-
wear Designer of the Year categories at the CFDA
Awards.

2019

Figures of Speech, an artwork-focused retrospective, opens
at the Museum of Contemporary Art in Chicago,
Illinois. The exhibition features new work alongside
unseen works from his past.

Also this year, he collaborates with IKEA to design a mix of everyday lifestyle objects designed to make a statement in a first home.

Abloh is nominated as a top five nominee in the Accessory Designer of the Year and Menswear Designer of the Year categories at the CFDA Awards.

2020

Abloh showcases his exhibition *efflorescence* at Galerie kreo Paris and Galerie kreo London.

From 2019–21 the *Figures of Speech* exhibition travels to the High Museum of Art in Atlanta, Georgia; the Institute of Contemporary Art in Boston, Massachusetts; and the Brooklyn Museum in Brooklyn, New York.

ACKNOWLEDGMENTS

First and foremost, my thanks go to Virgil Abloh, to whom the words and thoughts on these pages belong. It is an honor be a part of this unique opportunity to showcase his incredible mind and voice.

My heartfelt thanks to Athiththan Selvendran for his extraordinary presence and support throughout this project, and to Daniel Bellizio for his assistance.

I would also like to acknowledge my friends Lenny McGurr, Daniel Arsham, and Sky Gellatly, all three of whom were instrumental to this project, and who gave me the inspiration to include and connect Virgil with the ISMs series. Thank you as well to Shi Lei Wang, Nikle Guzijan, and Pete Brockman.

My sincere appreciation to the entire team at Princeton University Press, especially Michelle Komie, Christie Henry, Terri O'Prey, Cathy Slovensky, and Kenneth Guay. We remain extremely grateful to PUP for their continued professionalism, encouragement, and passion for our projects together throughout the years.

Very special thanks to Fiona Graham for her invaluable research and diligent organization of this publication.

Thanks as well to Susan Delson, Enrique Menendez, and Karl Cyprien for their editorial assistance, and to Amanda Scoledes and Aemilia Techentin for their supporting research. Thanks also to Franklin Sirmans, and to Kevin Wong, Keith Estiler, Sarah Sperling, Noah Wunsch, Vanessa Lee, and Man Hoang.

My sincere thanks to Taliesin Thomas for her amazing assistance on this and many other projects, and to Zara Hoffman, Steven Rodríguez, and John Pelosi for their continued support. My thanks as well to Paul Schindler for his support.

Finally, I give all my bottomless gratitude to my amazing wife, Abbey, and to my wonderful children, Justin, Ethan, Ellie, and Jonah for their love and encouragement.

As always, I give endless love and thanks to my mother, Judith.

LARRY WARSH

Virgil Abloh is an artist, architect, engineer, creative director, and fashion designer. After earning a degree in civil engineering from the University of Wisconsin-Madison, he completed a master's degree in architecture at the Illinois Institute of Technology. It was here that he learned not only about design principles but also crafted the principles of his art practice. He studied a curriculum devised by Mies van der Rohe on a campus he had designed. Currently he is the artistic director of menswear at Louis Vuitton and the chief creative director and head designer of menswear and womenswear concepts titled Off-White.

Larry Warsh has been active in the art world for more than thirty years as a publisher and artist-collaborator. An early collector of Keith Haring and Jean-Michel Basquiat, Warsh was a lead organizer for the exhibition *Basquiat: The Unknown Notebooks*, which debuted at the Brooklyn Museum, New York, in 2015, and later traveled to several American museums. He has loaned artworks by Haring and Basquiat from his collection to numerous exhibitions worldwide, and he served as a curatorial consultant on *Keith Haring | Jean-Michel Basquiat: Crossing Lines* for the National Gallery of Victoria. The founder of *Museums Magazine*, Warsh has been involved in many publishing projects and is the editor of several other titles published by Princeton University Press, including *Basquiat-isms* (2019), *Haring-isms* (2020), *Futura-isms* (2021), *Abloh-isms* (2021), *Arsham-isms* (2021), *Jean-Michel Basquiat: The Notebooks* (2017), and two books by Ai Weiwei, *Humanity* (2018) and *Weiwei-isms* (2012). Warsh has served on the board of the Getty Museum Photographs Council and was a founding member of the Basquiat Authentication Committee until its dissolution in 2012.

ILLUSTRATIONS

Frontispiece: Portrait of Virgil Abloh. Photo by Bogdan Plakov.

Page 130: Virgil Abloh, American, born 1980, *Cotton*, 2019, acrylic on canvas, Courtesy of the Gymnastics Art Institute

ISMs

Larry Warsh, Series Editor

The ISMs series distills the voices of an exciting range of visual artists and designers into captivating, beautifully made books of quotations for a new generation of readers. In turn passionate, inspiring, humorous, witty, and challenging, these collections offer powerful statements on topics ranging from contemporary culture, politics, and race, to creativity, humanity, and the role of art in the world. Books in this series are edited by Larry Warsh and published by Princeton University Press in association with No More Rulers.

Abloh-isms, Virgil Abloh
Futura-isms, Futura
Haring-isms, Keith Haring
Basquiat-isms, Jean-Michel Basquiat
Weiwei-isms, Ai Weiwei